D0987950

WAYS TO WALK IN LONDON

WAYS TO WALK IN
LONDON

HIDDEN PLACES AND NEW PERSPECTIVES

TEXT AND ILLUSTRATIONS BY

ALICE STEVENSON

1 3 5 7 9 10 8 6 4 2

First published in 2015 by September Publishing

Text and illustration copyright © 2015 Alice Stevenson

The right of Alice Stevenson to be identified as the author
of this work has been asserted by her in accordance with
the Copyright Designs and Patents Act 1988.

All rights reserved. No part of this publication may be
reproduced, stored in a retrieval system, or transmitted
in any form or by any means, electronic, mechanical,
photocopying, recording or otherwise, without the prior
permission of the copyright holder.

A copy of this book has been given to the British Library.

Book design by Claudia Doms

Printed in China on paper from responsibly managed,
sustainable sources by Everbest Printing Co Ltd.

ISBN 978-1-910463-02-4

September Publishing
www.septemberpublishing.org

To my parents, Caroline and Michael Stevenson,
for teaching me the value of good walks and good books.

Barnet

Harrow

Hillingdon

Brent

Ealing

C

Ke

Hammersmith &
Fulham

Kensington &
Chelsea

Hounslow

Richmond
upon Thames

Wands

Kingston
upon Thames

Mer

Su

Surrey

CONTENTS

Borough and closest Tube or train station are listed beneath.

INTRODUCTION

Walking has been an important part of my life for as long as I can recall. Whether specifically heading off for a walk or as a way of getting to a destination, it is an activity that both calms and inspires me, and alters my perception of the world.

Most of the walks in this book took place between November 2013 and July 2014, during which we negotiated the wettest winter on record. I chose my routes a number of ways, some almost incidentally, haphazardly wandering and getting lost, while for others I followed particular paths.

London and I have always had a strange relationship. I regularly dream of escape and feel overwhelmed by its unforgiving, grey vastness. But making a book about walking in London meant that I would not just be responding to memories. Instead, walking would be making them, as part of the creation of the book, plotting lines across the city as I investigated my complex relationship with it.

On each walk my inner world, the physical surroundings and, if with a companion, our relationship, combined with the motion of putting one foot in front of the other, created a unique experience and a subsequent memory. And through these walks, I found my sense of separateness from my surroundings gradually diminish, and my home town has become as rich and atmospheric as if I were experiencing it for the first time.

I have a fairly brisk pace and my focus shifts between observing the details of my surroundings to turning inwards to my own thoughts. As an illustrator

and artist, my work has always been largely – and unintentionally – based on observations of my surroundings with an abstract reinterpretation. I always seem to be seeking to capture atmospheres and memories. In creating this book, I set about doing this more purposefully, using the rich visual memories that walking creates as my starting point. The process varied from walk to walk. After some walks a clear image of what I needed to create would appear in my mind, whereas for others I'd sit down in my studio with recollections and photographs, and through a process of trial and error I'd eventually find the appropriate visual language with which to capture the experience.

This book is partly a personal travelogue. However it is also intended to be an unofficial guide to walking in London, these walks are starting-off points for you to have your own unique experiences amongst its lesser-known corners. I also hope for it to be an inspiration to any Londoner, visitor to London, or city dwellers anywhere, to see the potential for wonder and adventure available to all – just by stepping out of our front door with an enquiring mind and putting one foot in front the other.

ST THOMAS'S GRAVEYARD

FROM

MORNING LANE

TO

VYNER STREET

VIA

ST THOMAS'S RECREATION GROUND

Paragon Road is the least inspiring but most straightforward route to my studio. It's a typical Hackney mix; tower blocks, a modern purpose-built school and elegant Victorian houses. It's raining gently and I am trying to find something of interest or beauty. It's not too hard to engage. There are the twisting, bare trees in the Trelawney Estate lawn and Middle Eastern decorative elements on the restored houses.

It's more challenging on Mare Street. It's a charmless, noisy road. But my attention is grabbed at St Thomas's Square by a diseased young beech, white marks on its bark. There is also an iron gate by a church I've barely registered before. It's St John the Theologian, a Greek Orthodox church, which was built as a Catholic Apostolic church in 1873.

The gate's open and I wander between walls lined with bushes and topped with spikes. The path opens into a large, square churchyard, with a pink, mock Tudor hut in the middle, which reminds me of the similar gardener's hut in Soho Square. It's surrounded by overgrown grass. The gravestones are flattened up against the walls and each other, often hidden by overgrown spiky bushes and ivy. Dead ivy and brambles cover the walls, looking like veins on the brickwork. Behind one wall, the backs of Victorian houses loom up. I like this place, it feels secret and hidden, unlike the rest of this borough.

This is in fact St Thomas's Recreation Ground, the former burial ground of a long gone, seventeenth-century Nonconformist chapel. It was laid out as a public garden the decade after St John's was built, which is why the headstones, although not the tombs, have been moved. As I leave, the sun comes out. Reflected trees shine up from precise puddles and there are multicoloured cut-out paper snowflakes in a frosted school window.

REGENT'S
CANAL

MARE STREET

LISSON GROVE

REGENT'S CANAL

There is an energetic wind whipping our hair as we walk along Regent's Canal. This part between Mare Street and Angel is so familiar to me, the fishworks and the balconies and the barges. We diverge into Angel for lunch and then trace the canal's underground route, walking through shopping streets and the peaceful maze of an estate, knowing it's flowing beneath our feet – under layers of concrete, but still there pulling us onwards, until we rejoin its banks.

The canal cuts through different neighbourhoods, whose distinctive characteristics appear and evolve on either side of it, but it's really a world within itself. Its own locality, albeit with extreme dimensions of length and width. Pedestrians and cyclists are its transitory inhabitants, and moorings the settlements. At Camden Lock we are almost part of the market, the peace suddenly disturbed by shouting and the smell of food. A single wooden railing divides this nomadic canal realm from the tourists and the chaos. After the canal was originally opened, the first part in 1816 and the rest in 1820, numerous attempts were made to construct a railway line along the same way, but none of these plans came to fruition, leaving it a peacefully flowing artery cutting right through the city.

Around King's Cross, a backdrop of large modern office buildings is soon followed by strange wooden triangular structures that look like miniature Californian eco houses. We speculate inconclusively as to their purpose. I feel a sense of being deeply in the middle of somewhere, almost as if we are travelling downwards and not along, that this path is taking us deep into the earth. Moving towards Primrose Hill, we see the backs of Victorian houses, with happily ramshackle back gardens, complete with model farm animals, adding a sense of upmarket, bohemian jollity to the atmosphere, and the canal temporarily loses some of its austerity.

As we move further west, the landscape becomes leafier and it's nearly deserted in the late afternoon light. Trees line the canal, and it's much quieter here. We're not sure where we are. I feel a strong sense of nostalgia for the quieter parts of Berlin's canals, where I walked last July with my friend Ruth

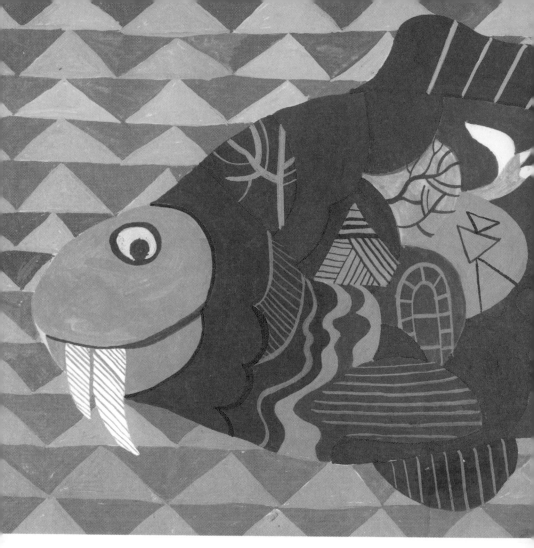

for hours in the hazy sunshine.

We pass the large Georgian-era embassies that loom over us in a stately fashion. Soon after the canal opens out, backwards towards the old Cumberland Arm of Regent's Canal, which was filled in with rubble from bombed buildings following the Second World War. The red floating Feng Shang Princess bobs gently on our left in its remaining stub, and the whole atmosphere is altered by there suddenly being a choice as to

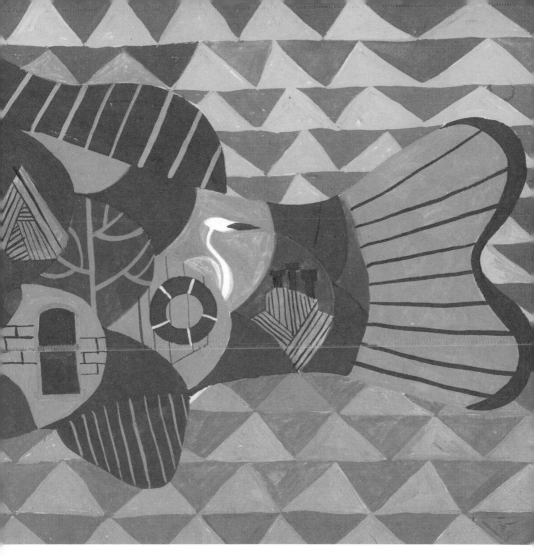

which way to turn. It's starting to get dark as we reach the cages of London Zoo, the most striking of the Regent's Canal landmarks. We are both tiring. As we leave I notice a decorative ironwork gate by the Lisson Grove exit, featuring a cheerful carp, a glass and a bottle of wine, a goose, a cat, a spanner. Highly symbolic and completely nonsensical. Still a permanent home to hundreds of barge dwellers, the canal has its own logic and sense of time and space.

PARKLAND
WALK

The Parkland Walk is a pathway along a suburban railway line that was abandoned mid-construction. I really can't visualise it, and Elinor and I enter an unassuming entrance to the bridge and climb up a narrow concrete building unsure of what we'll find. The view from the bridge opens up high over a railway line. All sense of where we are in relation to the ground is warped and unclear. This will turn out to be a recurring theme of this walk.

It's a muddy path, and it rises high enough so that we are generally about level with the top floor of the houses that lie behind the trees to either side. I like walking alongside the backs of houses, it makes me think of pulling a plant up and looking at the roots. This is the part we are not meant to see – the ragged, busy functionality of gardens, sheds, trampolines and rusty garden furniture, open windows and uneven paint – all hidden from the calm façade of the front of a Victorian London house.

We are flanked by an overgrown scrub-
land, full of berries, ivy and foxholes down
below. We pass an adventure playground on
the upward sloping bank amongst the ivy,
made of uneven planks with ropes hanging.
It's unoccupied and has a look of being built
by Peter Pan's Lost Boys. We stroll along
the never-used train platforms; the Park-
land Walk is a mid-twentieth century ruin.
A strange upturned railway bridge emerg-
ing ahead of us. This path is both deeply
functional and defunct. We are behind and

within the surface make-up of this city, a part usually the exclusive terrain of city foxes and rats. We pass a section of brick wall emerging from the muddy bank, covered in graffiti and entangled in roots of an old tree rising heroically from the brickwork.

We rescue a runaway miniature schnauzer called Stanley and befriend a large part of the Parkland Walk dog walking fraternity in the process through a communal effort to locate the owners. Luckily they appear after half an hour and Stanley is safely reunited. It is a happy surprise to find this long, thin

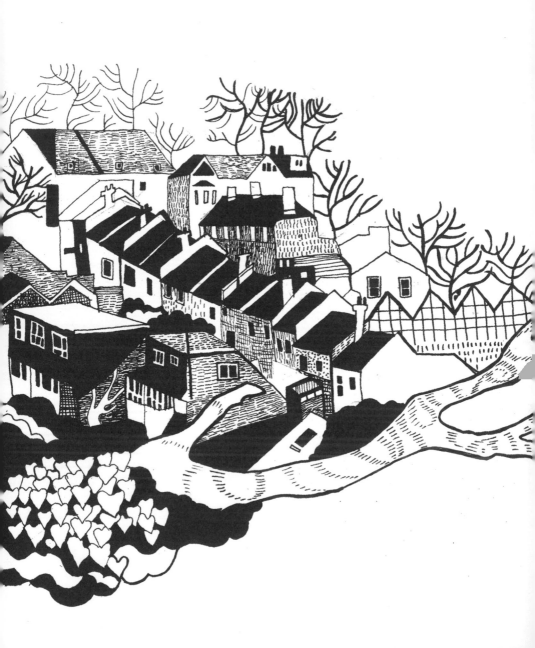

area does have a community, which you would expect from a more traditionally shaped public space but not a long path.

We finish part one of the walk and emerge back onto the streets of Highgate, and trace the invisible route that is temporarily swallowed up by pavement, cars, pubs and corner shops. We are in path mode, not freestyle ambling exploration. Walking a specific route you find yourself waiting for the experience specific to that path, which you share with your fellow walkers and everyone who has trod it in the past.

We rise higher and higher on the second shorter part of the Parkland Walk, and are greeted by a sea of rooftops at all angles around us and one of the most spectacular views of the city I have ever seen. It feels like surfacing after being underwater. The rooftops start to form patterns, and houses merge into a complex whole, losing their individual identities. The patterns turn into smaller marks the further out we look, separated by brown trees and interrupted by the grey oblongs of Canary Wharf, and then far into the distance to the south east onto the solid dark grey of the countryside before the horizon's edge. We walk back the whole way to Finsbury Park; it's like listening to a song backwards, but it still makes sense.

LOOKING DOWN

FROM
VYNER STREET
TO
OLD STREET

As I step out of the studio door I decide to focus on the ground below me on my walk. The concrete ground on Vyner Street is indented for a patch with tiny, symmetrical marks. As I walk out onto Mare Street and down to the canal, I am struck by what a wealth of different types of pavements there are, even in this small distance. Large hopscotch-esque squares to narrow little oblongs lined up in neat rows. A feast of geometric patterns in the concrete beneath my feet.

The dirty, reflectionless puddles on the canal path show up in dark contrast to the wealth of pale pebbles embedded into the regimented paving stones. Surrounded by dead leaves and twigs, I spot a flattened plastic bag which looks more like a sea creature or a fossil than discarded waste.

The chilly wind makes waves on the steel grey canal water. Weeds emerge valiantly between the pavement cracks and roots burst out of concrete on the canal path wall. A broken piece of wooden fruit box lies beside it, its weather-faded bright colours set off beautifully by the leaden backdrop. Back on the street I notice leaf shadows on the paving stones, like smears or ghosts of leaves. Whole blackened

dead leaves dot the pale grey sporadically. Where tiny leaves and cigarette ends have landed on the grid of the paving stones, they have become a series of surprisingly harmonious, separate compositions created entirely by chance. I think of how I revere the beautiful textures found on leaves and rocks, yet so often ignore the patterns I walk through every day.

Handfuls of scattered red berries and splatters of brightly coloured paint further break up the monotony of the grey. As I pass the soil and woodchip beds under the fences of Hackney City Farm, I am struck by how the characteristics of their contents gradually alters according to what particular part of hedge they are made up from.

Turning onto Hackney Road, bicycle tracks on the pavement make twisty, spirally lines. I am treated to a series of several circular patterned drain covers, one after another along the road. On this route I've walked unthinkingly so many times before, I've discovered a wealth of intricate patterns and marks left in the wake of human movement and plant life. This serves as a happy reminder that beauty is everywhere, if we only choose to see it.

HEARTBROKEN

Things look different when walking heartbroken or sad. It's December 2013 and I am cat-sitting for a friend in Kentish Town. I'd met someone I really liked and things were going well, but now he's ended it and I am sick with disappointment.

The world looks ugly and there is something really wrong about all the colours around me. It's a bit like hearing music that's out of tune. The light from cars, windows and streetlamps on Camden Road is a dirty, washed-out yellow that matches my mood perfectly.

There's no joy in the walk, but it's the closest thing to comfort I can feel. While in motion we are strangely safe, not entirely trapped inside a situation. The world is still fluid. Cruel thoughts pass through me, as do the emotions they generate, rather than fester and poison. The rhythm of my footsteps is soothing and creates a grid-like structure to the contents of my mind.

I keep looking down at shadows and I catch my own outline filled with dark branches.

The following day I walk to Hampstead Heath, taking an unintentionally circular route around Tufnell Park. The sky is bright blue, the light is intense, and long shadows are being cast around me. This is usually what I consider my favourite weather, but today I find the silhouettes and bright colours harsh and invasive. Instead of being uplifting, it is as though the weather is jeering. Yet as I walk all the same, a soothing rhythm kicks in and I feel as though the weight of disappointment is lifting a little.

The pruned trees with their deformed, stunted branches feel symbolic. But a surprising number of perennial plants have survived the cold, small signs of hope and renewal.

This route has so many different styles of building, I have a weird sense of being a tourist amongst the many strands of architecture; early Victorian terraces, 1960s concrete blocks of flats and late Victorian red brick with the odd dash of art deco. Then the odd, diagonal 1950s Gordon House as I turn towards Gospel Oak. The contents of my home city merge and overlap and have lost their familiarity today. It feels almost as if I've travelled to another city, like Glasgow or Paris. The same, but different. Small signs of Christmas, holly bushes, turned-off Christmas lights, make me wince.

I reach the heath and begin the ascent of Parliament Hill. I always forget the power of open spaces to lift my spirits. As I reach the top, the sadness sitting at the pit of my stomach is still there. But as I look out over London, there is something else, a sense that I'm acknowledging that some other state of mind and body is possible somewhere in the future. It might even be hope.

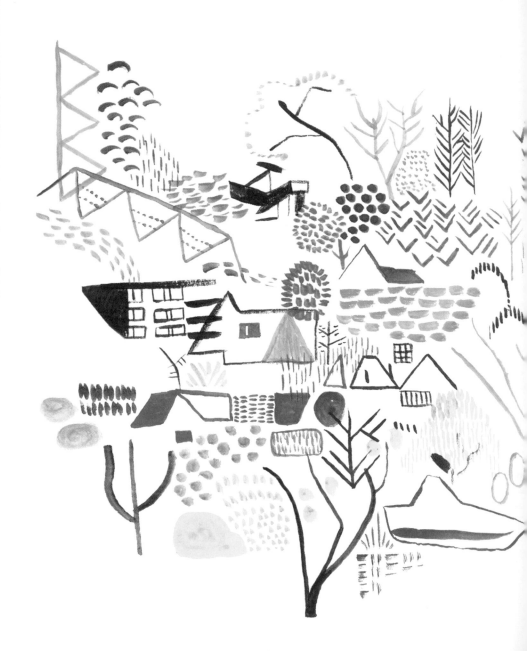

TEDDINGTON

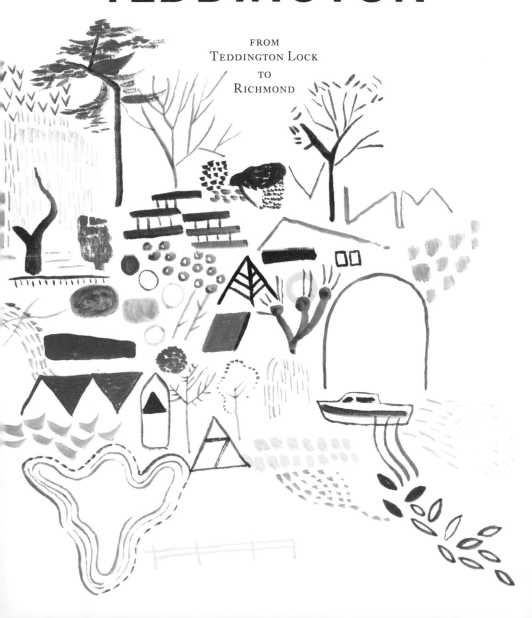

FROM
TEDDINGTON LOCK
TO
RICHMOND

At Teddington Lock, the trees and soft curved lawns combine with the footbridge's structure and the boats to create an atmosphere which is both picturesque and functional. We cross over the island to the opposite side of the Thames, and start to walk surrounded by trees that are just beginning to wake up in the early spring sunshine. On the bank we have just left, weeping willows and pine trees frame modern blocks of flats.

Soon we are walking through a brown jungle of leafless trees growing out of the bank at strange angles, some dead, some knocked over by the recent storms. A huge old tree lies dead on its side, and the cross section of its trunk is so indented it looks like an abstract flower or the outline of an island on a map.

Through the wild branches, across the river, the backs of large houses stand, reassuringly. They are surrounded by

films I loved as a child. It has a modesty and a makeshift sense of eccentricity. From the side of either bank it is loaded with promise, and seems to encapsulate some sort of happy place where I was always meant to live. However, like all seductive views, once you enter into the place and wander about, while still being a pleasant environment, the spell is broken and it lacks the magic promised from a distance.

green lawns, which drop down four feet into the water, where little jetties protrude and tasteful little speed boats are moored. I feel a yearning to live in this kind of idyllic nesting place, but it passes quickly.

We keep going, in anticipation of the first glimpses of Eel Pie Island. This is one of my favourite views. The timber boat houses and old boats give me a sense of nostalgia for the settings of

The path opens out to green on all sides and across the bank as we near Richmond. Across the water, Marble Hill House stands gleaming white, surrounded by fresh green grass. We are soon walking alongside more and more people, until we are in a mass movement of weekenders. The sense of being privy to a unique atmosphere is gone, and we feel like every other tourist.

37

CANARY WHARF

FROM
CANARY WHARF
TO
GREENWICH
VIA
ISLE OF DOGS

The escalators at Canary Wharf Tube station rise up so high there is a strong sense you're entering a different dimension. When I imagined the twenty-first century as a child, Docklands is the part of London that most closely resembles the futuristic city I envisaged – but the familiar café chains and the office workers are grounded in the everyday.

Being surrounded by thousands of squares of glass, all these shiny reflections, makes me feel more awake than being in the midst of brick and concrete. The height of the buildings is exhilarating too, but makes me feel a little dizzy, less certain of my step.

The attempts at creating green space in this part of London make me smile. There is a funny little park, with grassy patches surrounded by comedy winding stone walls, whose slightly too large proportions and complete lack of wear and tear make me feel that I'm wandering through a faux Bavarian village in Disneyland.

I walk down to the water's edge and over Pontoon Footbridge. I make my way down a nondescript road alongside Wood Wharf business park. Suddenly I've gone from a city of light glass to what feels like the least inspiring part of suburban London. Fenced low-rise office complexes and industrial sites.

At the West India Docks entrance I can see the O2 arena, wires protruding from a head in a primitive neurosurgical procedure. Skyscrapers loom but then at the water's edge, by Blue

Bridge, I see a road of terraced houses that look like they belong in a south coast seaside town. I cross the bridge and see another parade of Victorian terraces with a sad selection of shops. They would be completely unremarkable anywhere else in London, but here they seem like a last bastion of the Blitz, a remnant of a past world. I find this sinister yet slightly exhilarating.

The Isle of Dogs is one of London's strangest manifestations. Strolling along the river path, I regularly have to dive inland when the public right of way stops. I am exposed to the most fascinating architectural mishmash: brown-brick new builds in the style of traditional Dutch canal houses, followed by some sort of brightly coloured post-modern monstrosity, which appears to serve as a community hall. And you look out to the vast, wide River Thames, to dockyards, warehouses and distant green hills. There is council tree-trimming work going on here, with men in boiler suits. If it wasn't for them, I wouldn't have seen a single person on the Isle of Dogs. I reach a proper shingly beach, framed with ugly red-brick buildings, but I feel the same sense of independent joy I get when travelling and exploring alone hundreds of thousands of miles away.

Greenwich looms into view, asserting the historical importance of this location. An imposing marker on the Thames Path, bookending the city with Hampton Court Palace many miles west, it reminds me I'm in a 'proper' place instead of no man's land.

It's getting windier and I can hear waves lapping against the shoreline.

Island Gardens is a surprisingly pleasant little park by the foot tunnel, which has a very old mahogany-lined lift. The tunnel itself is unreconstructed, functional and gloomy. I hate being underground and have to march through, not letting myself think about the vast body of water above me. I come out to the *Cutty Sark*, a nineteenth-century landlocked ship, towering above me and I walk past into the wide-avenued dignity of the streets surrounding the navel college and maritime museum. Once again I am in an entirely different world.

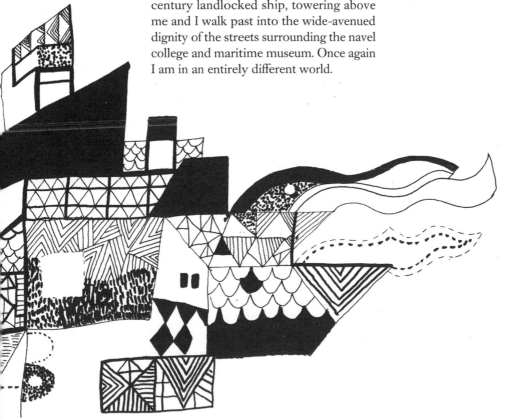

BROMPTON CEMETERY

I'm walking behind a well-to-do looking woman in a sheepskin coat and Hunter wellies who is pushing two chihuahuas in a pram. One has its tongue permanently sticking out of its mouth. Their owner is oinking at them like a pig.

One of the first things I see after turning into the Fulham Road entrance is a sign saying 'Some of the structures in this graveyard are unstable so please stick to the paths', so I immediately leave the path and start wandering amongst the graves, brambles and ivy.

Living and working in the jarring architectural mess that is Hackney, I have long since trained myself to find poetry in details such as a charming weed coming up between paving stones or the spire of an eighteenth-century church rising behind a 1970s purpose-built school. Here gothic charm is everywhere. I'm overwhelmed and I don't know which moss-covered Victorian angel or dead ivy veins I'm supposed to focus on. They all seem to cancel each other out. Then remembering that this used to be a notorious cruising ground gives the space a seedier context that I feel more comfortable processing. I'm almost relieved to see Chelsea football stadium emerge through the trees.

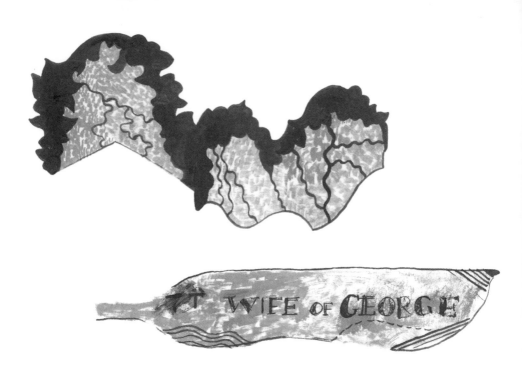

As I walk around, stumbling over semi-buried graves that have almost been completely reclaimed by London soil, I begin to realise that this is a miniature stone city, with different areas each with their own atmosphere. The south-east part is the ultimate in picturesque; clusters of mossy graves are indistinguishable from the ivy they share, carved inscriptions fade fetchingly into weathered stone, the odd words still legible … 'wife of George'. I am particularly pleased by the groups of tombstones underneath trees creating shadowy, mossy grave caverns.

I pass one stone in which about one third of each word is legible, randomly spaced like a 'fill in the blank' exercise. Then there are the graves against the cemetery walls that seem to be its introspective guardians, watching over the thousands of sleeping dead.

I cross over to the south-west part, the football stadium side, which has a very different feel. The graves are newer and more evenly spread, I feel like I could be anywhere and I'm strangely relieved, the relative blandness gives me space to gather thoughts and absorb impressions. I discover newer

spaced-out gravestones and wooden crosses carefully manicured, rectangular flower beds planted in front of them. Some are tastefully done, a fragrant lavender and rosemary herb garden. Some are somewhat half-hearted, a sheet of astro turf surrounded by white stones, a neat row of hardware shop pansies dwarfed by a large, blank expanse of soil, with a small bouquet of ferns placed in the middle.

I keep going towards the chapel. Its design was based on St Peter's Basilica in Rome and this contributes significantly to the sense of being deep within a tiny ancient city. I find the atmosphere in this part slightly frightening. The tombs all gathered in a large circle, there are a greater quantity of mawkish, blackened Victorian angels

and red, stone crosses. There is something menacing about their stance surrounded by the golden brick of the round circular walls. The cemetery was initially created as a response to the huge population increase in London after the Battle of Waterloo. The strain on the city's sanitation resources led to mass epidemics and a need for substantial burial grounds, and these monuments are an army of the Victorian dead. I am reminded of one of my favourite childhood books

45

Marianne Dreams by Catherine Storr, where an ill girl draws cyclopic stones on a blank background, which she visits in her dreams; one-eyed boulders moving slowly towards her across a bleak landscape.

I head back over to the east wall, back to the pretty side. I step up onto the raised path and head north. Looking down on the cemetery I have more of a sense of the sheer mass of the stones, of how their colours gradually alter from black to a washed-out reddish grey. As I head to the Old Brompton Road exit, I am leaving the heart of this grave city for politer almost suburban areas. The sound of traffic takes me back to the humdrum and everyday, and it's only now I realise how far away I felt in the middle of that place. The grass is less overgrown here and I notice squirrels rushing about between graves and up trees. There are still a few Victorian death angels dotted about. I find my favourite, she is understated and slightly dumpy, I warm to her more than I have to any of the others. I pass a lot of six-pointed cross shaped marble gravestones, which I later learn are Russian Orthodox crosses known as the suppedaneum cross. I like their odd yet very specific shape. Like the Russian alphabet, as symbols they are both familiar and alien. I head out of the gates and the half circle of Earls Court Exhibition Centre looms inelegantly in front of me.

WOOLWICH

view is blue and grey, industrial colours and block shapes. Out across the river the expanse is wide, with pylons dotted in the distance. The Tate & Lyle factory looks like a giant bottle. It's one of the oldest, still functioning factories in the city, and looking at it I feel a real sense of London's industrial past, which often now seems so remote. In front of it is an old wooden jetty on which sad brambles attempt to grow.

The Thames Barrier shines like metallic wedge-heeled sandals across the water, keeping all of London safe and dry. Its surfaces shimmer, creating an ethereal atmosphere in such a prosaic setting. We pass a tarmac factory, all primary colours in bold simple shapes like it's made out of Duplo.

Compared to the other end of the Thames, at Woolwich there is so little green. Woolwich was once a leading industrial area, home to the Royal Arsenal, the Royal Artillery and the Royal Military Academy, which all came into being in the eighteenth century. The scaling back and eventual closure of these institutions in the last century led to Woolwich's decline and it became a run-down area with high levels of unemployment. At the river's edge, the

Another jetty reaches out to the water. On it stands a grey clapboard shed-type building on stilts. I have no idea of the purpose of much of what I'm seeing on this walk, I am just wandering through brutal, abstract shapes and structures that have their own logic, that seem devoid of everyday human interaction, but quietly dignified. I realise I keep thinking of the river as the sea, maybe it's the width and the gentle lapping of the water, and a sense of not knowing what lies beyond.

Down on the shore is a sculpture made out of bits of driftwood, fishing rope and tyres. It's a sign at least one other person has considered and engaged with this strange landscape.

We reach Greenwich, London's city seaside town, and people with pints, cyclists, children and signs of merriment emerge with increasing regularity. The friendly, peopled world embraces us warmly, yet I have enjoyed the walk; one of the most peaceful London experiences I have had in a while.

RICHMOND
PARK

It is around midday on Boxing Day. My family and I head out for a walk in Richmond Park. It is colder than we imagined; I relish the chill on my cheeks and the wind seeping through my jeans onto my legs. The sky is slate grey and the ponds reflect this. The orange of dead ferns and the dark brown of the leaf-covered ground combine pleasingly, and there is nothing depressing to me about these bleak colours.

Richmond Park is the largest of London. I lag behind a lot or join in the conversation as I feel inclined. Sometimes we are all in silence and Topsy, my parents' aged but sprightly Patterdale terrier, circles around us gleefully, sniffing everything she comes across.

I feel the strongest sense of 'family' or togetherness that I have all Christmas. As we stride around I feel as though we are a tribe, and there is so much love and camaraderie amongst us all. The freedom to roam in this park creates a sense that we have chosen to be together as opposed to being stuck together, as is so often the way at this time of year. Thankfully the mud is too thick to play 'Mrs President', a game invented by my brothers in this very park, which involves them rugby-tackling me to the ground with cries of, 'Get down Mrs President, it's a sniper!'

We pass a small group of stags relaxing in the bracken, and when my brother Joseph and I walk closer to take a photo they stand up, staring right at us, defiantly. We feel alarmed enough for it to be fun, and make a hasty retreat. Later on in the walk we stumble across a tall, branchless, dead trunk of a tree. There is something imposing and symbolic about it, almost like a totem pole.

When we are nearly back at the car park, my eagle-eyed father spots a lone pair of antlers in the distance, emerging from the bracken. We get closer and see it is an elderly stag reclining amongst a textured sea of dirty orange. It is a melancholy yet dignified sight that somehow symbolises the sense of open space and freedom of this place.

PUB
WALK

We start our pub crawl at the Charles Lamb on Quick Street, north of City Road. Outside, the sun bounces off browny-red tiles and sweet peas peep out of the ivy-filled window boxes. This pub is a dear favourite of mine, small and understated, with delicious French food and the nicest bar snacks in town.

Like so many English pubs, its name is a link to the past. Charles Lamb was an eighteenth-century writer and essayist, and nearby resident. He suffered from mental illness himself, but his sister Mary had severe bouts and during one she stabbed their mother in the heart. Charles was devoted to his sister, and when she was periodically released from the asylum, they lived, worked and socialised together. This fascinating and shocking piece of history, captured however tenuously in the establishment's name, somehow adds an extra element to a sunny drink in a London pub.

We trot over Regent's Canal via the Danbury Street bridge, nearly blinded by the brilliant evening sunlight. Willow trees shiver like mirages over the water, in which a silver line of cloud is gleaming. Our next stop is the Island Queen on Noel Road, just north of the canal. Another firm favourite, originally a nineteenth-century gin palace, it is still high-ceilinged with chandeliers and intricately engraved glass. It is also allegedly the only pub in the world to bear its name and to me it suggests a link to Britain's colonial past.

It seems to fit with the heritage of this part of London, which developed into a popular pleasure resort from the seventeenth century onwards, spawning gin palaces and taverns, theatres and brothels. This pleasure-seeking tradition is still in evidence, particularly on a late sunny Saturday afternoon. Sitting out the front a large stag party dressed as characters from Super Mario Bros. swarms around us.

Back on the canal we are heading towards De Beauvoir Town. The landscape changes, on either side of us the rigid geometry of converted warehouses and modern office complexes glisten in the evening light. We walk up a slope to the corner of Shepperton Road, and sit outside the Rosemary Branch and drink white wine. In the seventeenth century, the original Rosemary Branch tavern was a meeting place for the radical dissenters the Levellers, their symbols sea-green ribbons and sprigs of rosemary. The current pub was built at the end of the nineteenth century with a minor music hall upstairs.

I like it as it's off the beaten track, tucked away. We look out at the imposing Victorian factory buildings of the Rosemary Works, now converted into loft apartments and an independent private school. Behind us the functional 1960s De Beauvoir Estate formerly announces that we are about to enter the borough of Hackney.

MIST

Looking through the mist, down the Trel-awney Estate, at a faint suggestion of The Globe in Morning Lane pub, I like not really being able to see what's in front of me. The mist blanks out much of the surroundings and it looks as if it could be facing a seafront instead of a busy road in front of miles of urban sprawl. A sickly sun shines in the distance. A pale disc in off-white.

You can only engage with what is in front of you. I see people walking in the distance like figures in a landscape painting, or like ghosts. It makes me feel incredibly happy. I decide as I walk that I would love it to be foggy about one day a week. There is a dreaminess and a sense of uncertainty. When we walk in a familiar landscape in the mist, we know what lies ahead not through sight but through memory. I find this creates space to wonder what is beyond the most familiar landmarks, it ignites a fresh sense of intrigue and engagement with the everyday routine.

It amazes me what fog can do to my perception of the world and my relationship with my surroundings. Walking in extreme weather can transform a place and make me feel that a place is somewhere different every time I walk through it. In mist, the world seems rich with possibility, albeit in a gentle and slightly melancholy way. My old friends, the bare oaks and chestnuts of London Fields, have taken on a new spectre-like dignity and Regent's Canal becomes a strange tunnel-like experience; the gasworks which normally come into view gradually on clear days, suddenly appear majestically right in front of me.

DEPTFORD

I meet Hannah in a coffee shop on Deptford High Street next to the station. She is my guide to Deptford and the surrounding areas. It's one of those parts of London I have listened to people discussing and it already has a place in my mental map of the city. I picture it dark, existing under arches and semi-underwater, so when I finally arrive here it has a vibrancy and lightness to it that surprises me.

Deptford was originally a fishing village, the area gradually grew and a dockyard developed which prospered from the sixteenth to the nineteenth centuries. This colourful and thriving maritime neighbourhood gradually declined at the beginning of the twentieth century and suffered severe bombing in the Second World War, leaving it victim to the brutal town planning of the 1960s. In the late twentieth and early twenty-first centuries it has been a place of high unemployment and poverty, but echoes of its proud past are still apparent as we wander its streets.

It's market day on the high street; stalls sell buckets of dogfish, and other skinny fish that look like they are still alive and are about to start leaping around the road. Market sellers chat happily around them. We pass an Asian fishmonger where hundreds of fish are displayed beautifully according to type across a table of crushed ice. Past the House Wives Cash & Carry, the most politically incorrect shop I can recall seeing in London. The side of an end row of Victorian terraced houses is painted pink with a string of pearls painted under one chimney and a polka-dot tie painted around the next, as if they are necks.

Around the corner at the market, hundreds of shoes and boots are piled up in heaps, beautiful old suitcases, old furniture, strange oversized Venetian masks painted the colours of flags or covered in glitter are attached to hat stands. There are mysterious, grubby-looking plastic bottles of perfume and books about political science. There is

a sense of happy, down-at-heel chaos that I find comforting.

We head back down the high street, passing Adonai One Stop Religious Store. Turning off down to St Paul's Deptford and wandering through the churchyard, its quietness feels like we've stepped into a different realm. St Paul's is considered one of the finest examples of Baroque architecture in London, built in the early eighteenth century as a counter to the increasing number of dissenters amongst the

dockworkers. The ornateness is highlighted by the ugliness of the surrounding area. Walking up the steps, looking between the columns at the entrance, are rows of carved daisy-like flowers.

We go under old railway arches towards Deptford Creek. Each arch we pass under has the outline of a bricked-up arched doorway beneath it, suggesting a past alternative network of paths beneath them, some sort of secret history that has been blocked off.

We cut into a park to get to the creek. On a wooden stump at the side of the path are the inside remains of an old typewriter, rusted orange against the wood. A 'swim clockwise' sign leans against it as if to direct how we

meet a council estate and a blue metal footbridge, which we cross. An imposing, grey Victorian building stands alone behind a metal, spiked fence with scrubby grass.

On towards Greenwich, through industrial sites and backstreets. The clock tower of the old Borough Hall looms over the lower buildings, seems to appear and disappear, adding to the pleasant sense of disorientation. We pass an upside down pineapple impaled on a spike above a wire fence.

We reach Greenwich Market. The covered market came into being in the early nineteenth century so that the busy traders of the area could all be under one roof. Now, the tourist bustle and the stately elegance of our surroundings make it feel like coming up for air after being underwater, yet in the hub of the market something of the bawdy dockyard atmosphere remains.

walk. When we get to the Creekside Discovery Centre it proves to be a large shed-type building, with detritus pulled up from the creek piled up on wooden shelves outside. Rollerblades, traffic signs, old kettles and tennis balls. They sit there as a museum to everyday life.

Walking to the left of the centre, down a side road, we're accompanied by railway arches and now industrial buildings. There is a rich stripe of green weeds where the walls meet the ground. I peer under a railway bridge and there are shiny, brightly coloured buildings in the distance. The walls of the creek are a patchwork of weeds, red brick and rust. The water's edge meets a low bank, which comes up to

RAIN

FROM
MORNING LANE
TO
VYNER STREET

I set out to the studio. It's raining steadily, as it has been for most of this post-Christmas period. I always find this time of year disorientating and I am glad to have work to do in my warm studio. It's unforgiving out here, the raindrops are large and come fast from every direction, and the wind blows them into my face.

I set off to take my favourite route through London Fields. A long flat park dotted with stately chestnuts and oaks, creating canopied walkways. Once pasture land for cattle, it now is arguably the epicentre of the gentrification of the area, containing a heated lido and in the summer bursting with fashionable picnickers who've travelled from far and wide just to sit on this patch of grass. It is also a site of gang murders and violence. I like it here in the morning, when it's just the dog walkers, commuters and drunks.

Weather-wise this day is pretty much unredeemable. I look down mainly to avoid the rain blowing in my face. On Mare Street I was vaguely aware that the surroundings were being mirrored up at me, but it was just ugly brown buildings mixed hazily with ugly grey-brown paving slabs, and failed to make any real impression. Now I am walking along the park, I see that the majestic, leafless trees are reflected on the ground beneath me. They are blurred and appear both ragged and washed out, but their graphic quality has a bold striking presence.

When you walk up to a reflection and purposely look into it, it loses any definition. They are best viewed from a distance and at a sharp angle, like shadows. But although indistinct and trembling in the rainfall, there is nothing ghostlike about these trees. They are too earthy. They seem more like smears or old stains. In this hideous weather the world above is merging with the ground, sprinkled with cigarette ends and dead leaves, telling me a strange story.

When I walk under the Mare Street bridge of Regent's Canal, and I'm about to leave the canal to turn into Vyner Street, a swan floats towards me through the grey dappled water, closely followed by three teenage cygnets. Their brown, smear-like markings echo the colour scheme of the blurred reflections I've been walking through on my way to work. The bottom half of my jeans and my trainers are drenched but I'm glad I walked.

REGENT'S
PARK

FROM
PARKWAY
TO
REGENT'S PARK

It's early spring, 7 a.m. The drabness that descends around me so regularly in this city seems set to stay for the duration of the walk, if not the whole day. We head down Parkway clutching our coffees. The Dublin Castle looks grim in the morning light.

As we approach Prince Albert Road we can see our first glimpse of soft grass; it's lush and very green, yet the grey sky adds a murkiness or shadow to the tone.

We enter the park at the Gloucester Gate entrance. Green spreads out before us, horse chestnut trees heavy with blossom. The outline of office buildings only just visible on the other side of the park. A mass of thick branches are randomly arranged in a home-made climbing frame construction that seems

somewhat incongruous in the tidy park surroundings. The way I'm feeling, it's as if I were walking across a sludge-coloured damp desert. The closeness of the sky makes me feel as though we are indoors in a giant marquee or dome with an absence of natural light.

The Broadwalk crosses another path and a large ornamental fountain comes into view. Our sad, muggy green and grey world is invaded by an explosion of colourful formality. We have arrived at the start of Avenue Gardens, smart planted gardens that lead up to the Outer Circle exit of the park. Regent's Park was conceived in 1810 – it was to be a private residential estate set in private parkland, owned by the Crown. A small summer palace for the Prince Regent was planned for the

southern end of The Broadwalk, but it was never constructed. When the park was partially opened to the public in the mid-nineteenth century, William Andrews Nesfield was commissioned to create a formal garden along The Broadwalk for the enjoyment of the public passing through.

I feel as if I am walking through a three-dimensional textile pattern. Circular flower pots are held up by stone griffins, bright red tulips are surrounded by circles of primulas, with a lower layer of heuchera leaves. Long rectangular beds are arranged with alternating coloured tulips and tiny circles of bellis daisies. The world has exploded into a riot of bright pinks, reds and deep purples against rich greens.

We become almost delirious at these amazing geometric shapes filled with soft flowers. Winter and its endless grey sky, pavements and buildings has had a numbing effect. I feel the colours flooding through me, and we walk out of the park nourished and content.

FOREST HILL

FROM
FOREST HILL
TO
EAST DULWICH
VIA
HORNIMAN MUSEUM

When I meet James in Forest Hill station, he says we are going to wander in the direction of East Dulwich. He is leading the way and I'm banned from Google Maps. It's late February and spring is in the air.

We start along London Road, and after about a hundred metres spy a tree-lined pathway heading up a hill. In the spirit of adventure we decide to take it. An ivy-clad alleyway complete with fallen beech trees opens onto the Shackleton Close 1920s flat complex, with well-kept grounds and dramatic views. This is going to be a recurring theme of this walk: alleyways opening out onto expanses of green and large vistas. We follow a route up wide streets of pre-war suburban semi-detached houses, sporting a surprisingly large array of monkey puzzle trees – native to the Chilean Andes, they were introduced in the nineteenth century and went on to become the height of bourgeois fashion.

In the sunshine, this suburban landscape feels comforting and hopeful. We descend the hills into quiet villagey streets, and find a green sporting a giant spider's web climbing frame in the Horniman play park. There is something of the idealistically cosy yet slightly shabby London of children's illustrator Shirley Hughes to this area. It's gentler than the city's starker reflection on the north side of the river.

Over the road lies the square formality of the Horniman Museum, an Arts and Crafts style building filled with Edwardian tea heir Sir Frederick Horniman's extensive collection of curiosities acquired on his travels. In the gardens, there is a sense of being nestled in a green blanket of a suburban valley, scattered with crocuses and snowdrops. The North Downs don't begin for several miles south, yet the landscape reminds me of childhood walks in Surrey – I think of how millions of fossilized sea creatures are

buried deep within the London clay and chalk under our feet. The Horniman's conservatory twinkles in the sun.

Wandering down a hill and up a hill I like having only the vaguest idea of where I am. James and I are drifting over the folds of a giant patchwork quilt.

As we enter the centre of East Dulwich we're re-entering the present day, passing gastropubs and giant buggies, and the strange sense of timelessness or lack of context from earlier is gone, but that's OK, as it's time for the first outdoor pub lunch of the year.

WALKING A LINE IN
CHELSEA

I draw a wiggly, meandering line in my notebook which almost closes in a circle. I impose it on a map and set out to follow it.

Walking down the side of Chelsea and Westminster Hospital, past cars going in and out of the entrance to the car park, I realise I'm still on hospital property. On my left a raised, formal concrete garden emerges. Trees and flowers cast dappled shadows on a man in scrubs who sits smoking in the brilliant sunshine. Around the back of the hospital I come across buildings that are immediately identifiable as a day centre of some kind by the display of ceramic objects and murals that adorn the walls.

This well-meaning shabbiness is short-lived as I follow my line and turn into Gertrude Street, where front gardens are beautifully landscaped and Mercedes glimmer in the morning light. The neat white terraced houses on Limerston Street line up immaculately with tastefully old-fashioned street lamps, evenly spaced. I turn left, down past the reassuring red-brick mansion blocks on Camera Place and I turn down Chelsea Park Gardens, with perfect Arts and Crafts cottages, flanked again by shining silver

cars. In this area formerly inhabited by bohemian artists such as Dante Gabriel Rossetti, William Holman Hunt and James Abbott McNeill Whistler in the late Victorian period, now it's so immaculate I almost feel I'm in a film set version of London. Wisteria is in abundance, draped over porthole style windows.

Following my home-made map helps me to explore without judgement, and put concepts of class and gentrification aside. It's easy to dismiss the hyper-wealthy areas of London as not being real or authentic, but perhaps this is a pointless perspective as defining a true London existence is an impossible task. Aided by sunshine, I just enjoy architectural details and flourishes for what they are, today, on this spring Monday morning in April.

My eye keeps being drawn to details that jar with the harmonious surroundings. A flattened, dead camellia lying on the pavement and a group of plastic buckets, in which browning dead mossy weeds are growing, perched on a low wall.

Walking this way there is a gentle thrill as you turn a corner directed by your hand-drawn line. Walking along Beaufort Street towards the river I am drawn to the decorative mouldings that adorn Winchester House flats. Cherubs and heraldic shields are clustered within, surrounded by plaster leaves. This street is on the former grounds of Chelsea Manor, home to Elizabeth I.

My map leads me to Cheyne Walk and Crosby Hall. I admire the trident-bearing

goat/stag creature with a merman's tail that reoccurs, carved in stone and on golden shields carried by lions. Latin is carved into the bottom of the windows. Crosby Hall was originally built in Bishopsgate in the fifteenth century by wealthy textile merchant Sir John Crosby. It was moved brick by brick to Chelsea in 1910. I like not knowing what these bizarre creatures are, and how serious and symbolic the whole decoration is, many miles from the mundane, cost-efficient functionality of buildings that are now built in London.

Contrasting sharply to Crosby Hall is the calm modernism of Ropers Gardens, created in the 1960s as a memorial to the bomb-damaged buildings that stood there before the war. This is a composed, dignified space. I marvel at how within a couple of footsteps I slip between such different atmospheres.

Away from the river I wind through the quiet, mews streets around Cheyne Row. I hone in on little decorative flourishes which individualise each house: a moulded shell, maritime motif over one house; a small relief, a Grecian style portrait of a woman against a blue arch above a ground floor window on another. Following this line, I am walking only a small distance as far as the crow flies, but my winding exploration of the streets alters the scope

of my gaze to details, and every building I pass is loaded with narrative and interest. A grating on the side of a red-brick Victorian building has a look of block-printed fabric.

My line takes me down towards the Chelsea Physic Garden, a walled botanical garden dating back to 1673, which is sadly closed today. I am struck by a building opposite I've somehow never noticed. It's in the style of a traditional Dutch town house. I look closer at the decorative ironwork on the front door and feel almost hypnotised by the twists and turns of the metal.

Back up towards the King's Road, then past towards South Kensington, the streets of 1920s mansion blocks are wider and more trafficy. They still have the up market elegance of this area but I suddenly feel small and anonymous, like I am in New York, not London. I become focused on my destination and stop noticing small features of my surroundings.

HENDON

FROM
HENDON CENTRAL
TO
GOLDERS GREEN

Elinor and I have decided to go for a walk in Hendon. It's a suburb of northwest London we have little knowledge of or connection with. Its appearance supposedly embodies typical London suburbia and it also has the densest Orthodox Jewish population in the whole city. We are intrigued by this juxtaposition and want to experience the atmosphere of such a place.

We walk up Queen's Road and decide to turn off into Hendon Park. A series of bright green outdoor gym contraptions are lined up in one corner of the grassy expanse, and it's just us and a darkly clad couple with a pushchair in the distance. We cross the sloping park heading downhill, being pulled in the direction of the River Brent. The view ahead is of abundant greenery with red tile roofs peeking out, the darker green distant hills of Hampstead rise up behind. Much of the grass around us is long and overgrown, creating a comforting softness.

We turn off into Shirehall Lane, not a soul is around and roses bloom in the front gardens of 1930s semi-detached gardens. The omnipresent symbol of suburban respectability, the monkey puzzle tree, soon crops up in front of a black and white mock Tudor house. We pass one front garden which is concrete except for a tear-shaped flowerbed full of dying roses. It looks almost like a motif in a chintz fabric.

It's so quiet. We relish the peace, but it's so unusual we can't help wondering if the reasons for it are sinister. Steps lead down to the bank of the River Brent. It's almost an underground waterway, the banks are dark and green with white light shining in through gaps in the leaves. A little round brick hut in disrepair nestles by the water's edge. There is no way to walk along the river from here so we head back up, emerging into the bright daylight, happy to have glimpsed Hendon's almost subterranean layer.

Ignoring spiral steps that loom up, going over the North Circular, we head back up to the main drag and start to notice some extremely smartly dressed families and young children in party clothes. The architecture is largely 1920s and 30s semi-detached or blocks of flats, with a hint of Arts and Crafts. Less pristine than nearby Hampstead Garden Suburb, there is a combination of shabbiness and aspiration, grubby pillars added onto the entrance of a house with a concrete front garden.

On Danescroft Avenue we come to a 1960s concrete building which turns out to be Hendon Reformed Synagogue. Blue-and-white striped shawls and menorahs are in the windows, and a large part of one wall is a white semi-relief pattern made from geometric menorahs. These are our first indications of the strong religious community that resides in this unassuming area.

On Brent Street we look for something to eat, and start to see more and more people gathered around chatting,

dressed smartly, the men in large-brimmed black hats. The kosher bakeries we have sought out are all closed and it slowly dawns on us that we are in the midst of a religious holiday. We later discover it is Shavuoth, a minor but still observed Jewish festival.

We are cultural tourists – we live so close in terms of miles, but so differently that we've unknowingly wandered into a holiday. We are used to living alongside varied religious communities in London, but what's strange here is that for the majority of our walk we don't see anyone who doesn't appear to be part of this one. We are outsiders, but while this is slightly disconcerting, the sun is shining and there is a harmonious sense of community and belonging in the air which we rarely experience. We are happy we live in a city that can house and tolerate such varied cultures.

Barely acknowledged, we feel like invisible time travellers as we walk towards the overpass and Golders Green.

SHADWELL BASIN

FROM
WHITECHAPEL
TO
LONDON BRIDGE
VIA
SHADWELL BASIN AND WAPPING

We meet at Whitechapel station. A man is playing saxophone and his Staffie is barking along to the music. It's charming but headache inducing, and seems wholly appropriate to this neighbourhood. Whitechapel High Street teams with market stalls selling cheap fabric and halal meat. To escape the crowds Alma and I head south, past the shining blue oblongs of the Royal London, down a functional street lined with car parks. There is a bright green ironwork hospital fence in which naïve shapes of birds and sea creatures have been cut.

We wind down Cavell Street, heading south-east. Buildings are impossible to place in their period. We pass two terraced houses with elements of both Arts and Crafts and Georgian features, with blue and turquoise tiled doors reminding us of tenement entrances in Berlin or Scandinavia. Contradictions are rife in all parts of the city but perhaps no more so than in this part of London. We are in the heart of the East End, historically one of the most impoverished parts of London, notorious for its horrifying slums in the eighteenth century. For centuries new waves of immigrants have found their home here and in 1936 residents raged against Mosley in the Battle of Cable Street.

It's quieter down here today, walking around Jubilee Street. It's harder to define than the brightly coloured multiculturalism of Brick Lane. Not entirely gentrified, it's clean and quiet, giving it a certain shabby respectability. We weave under stairwells through council estates. Bleak edges are softened by the abundance of late spring greenery. We pass an abandoned yard filled with junk and a sea of yellow flowering weeds.

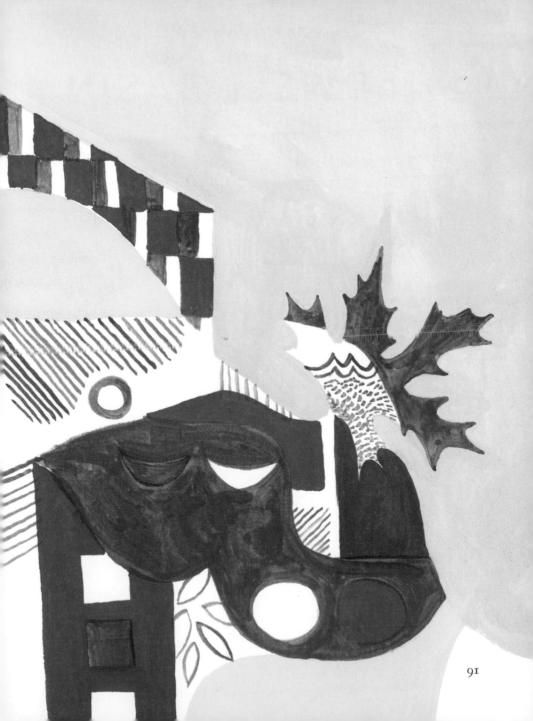

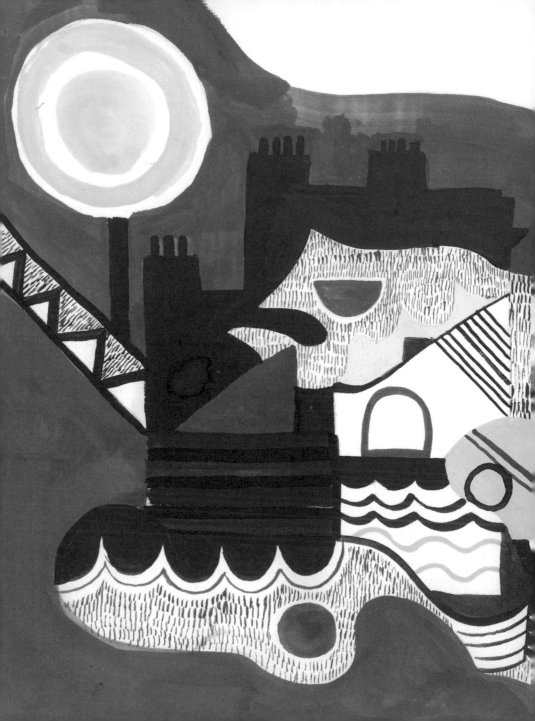

On Commercial Road, in Shadwell now, I am struck by the abundance of elegant Georgian architecture. Yet this part of town feels forgotten. The George Tavern stands proud. An ancient pub in which Dickens and Samuel Pepys allegedly drank. Rebuilt in the Victorian era, it is now a performance art venue. The unvarnished wooden window frames are beautiful against the faded brickwork.

The Highway heads east, a grey concrete council estate on our left. The owners have customised their homes to extremes, one flat has brown timber panelling and panes of bullseye glass. Another has stained glass and extensive flowering balconies. We stroll across King Edward VII Memorial Park to a bend in the Thames. Omnipresent Canary Wharf gleams in the distance and across the river the modern wharf buildings of Rotherhithe stand on wooden stilts.

Back inland, we head towards Shadwell Basin and discover one of the most strangely beautiful London sites I have seen so far. The basin is one of the few London docks not to have been filled in. Barriers to the water are just rope, and seem delicate in the evening light. It's surrounded by trees, and the spire of St Paul's Shadwell rises up behind them. A solitary swan rests peacefully out on a jetty. Postmodern warehouse constructions reflect blue,

red and gold, making geometric patterns that remind me of African textiles.

A 'red metal', an industrial bridge, leads us over to the Prospect of Whitby for a quick drink. It's London's oldest riverside pub and, as we sip white wine, we imagine it being full of pirates and smugglers instead of tourists and respectable families. The red-brick, Victorian industrial splendour of the former Wapping Hydraulic Power Station towers above us, further enriching the skyline. After closure in 1977 it became the Wapping Project, a fertile arts space. Then in 2013, after thirty-five years, it was sold to property developers. It is now more executive loft apartments. We wonder if all the interesting parts of London will become exclusive to the very wealthy, not for the ordinary city dweller.

Narrow pebbled streets take us towards Wapping High Street. We weave between high street and river; this was once all dockland too. The warehouses are so distinctive. I notice bold graphic shapes – typography, big yellow lanterns on the river. A red piece of wood poking over the wall like a shark fin.

Later, when it's dark, we walk over Tower Bridge, and it seems as if the world is in inverse, bright lights on black. As we walk along the river path towards London Bridge, sections of HMS *Belfast* look like a series of glowing, abstract shapes, separated by darkness.

BOOKSHOPS

FROM
BROADWAY MARKET
TO
ARLINGTON WAY

AND

FROM
LOWER SLOANE STREET
TO
LAMB'S CONDUIT STREET

It's a Saturday and the Broadway Market is in full swing. Donlon Books specialises in the esoteric and unorthodox. It's a bastion of genuine counterculture in this increasingly cosy and bourgeois street. Inside we inspect an early copy of Andy Warhol's *Interview* magazine and I leaf through some zines.

Out past the organic food and sourdough bread stalls to Artwords, a slightly more mainstream art, design and coffee table bookshop, which also stocks a beautifully curated children's selection. There is usually something by Tomi Ungerer on the shelves and I'm pleased to see a copy of *Moon Man* at the bottom. I feel slightly overwhelmed and become mesmerised by a coffee-table book about shamanic regalia, wishing I could sit down now and draw the feathers and shapes of the masks.

A couple of doors down we head into Broadway Bookshop, my favourite and my local. So many afternoons I've popped in on route to the post office and come out guiltily clutching a new purchase. Though a very small shop, they always seem to stock everything I could possibly want. Katie discovers a collection of short stories about cats and I have to stop myself buying about five different things.

We walk down to Hoxton Square and into bookartbookshop, which specialises in artist's books and small press publications. It's quiet and full of publications of vastly varying sizes. I find a book about limericks and start to read some out loud but stop midway when one becomes too lewd, causing the shop assistant to laugh loudly. I flick through a tiny volume which has obscure

commands printed small on each page. 'Borrow a book about airplanes at the library, comb your hair back.'

Books are the second best thing in the world to people, and to be in a bookshop is to be in a space where worlds are contained within small, paper objects, creating an atmosphere which is deeply exciting as well as peaceful and comforting.

We walk up to Arlington Way off Pentonville Road to Present & Correct, which largely sells unusual and vintage stationery, but also a marvellous selection of mid-twentieth century children's books. I swoon over *Nature* by Alain Gree, a 1960s informative picture book full of beautiful illustrations, and discover a children's picture book by Saul Bass. I am happy and I need nothing else.

of the Penguin Great Ideas series. Ross buys a thriller about gangsters largely because he likes one of the gangster's hairstyles on the cover.

We cross Belgravia, stopping at a pub, then on through Mayfair to Maggs Bros. on Berkeley Square who deal in rare books. I'm not quite sure what to expect and we are ushered upstairs to a room bursting with antique publications. We are the only people in there, and self-consciously look through shelves of old Japanese books admiring the patterns on the covers. I spot

Another day Ross and I walk to John Sandoe, a gem of an independent bookshop on Blacklands Terrace, just off the King's Road. Like Broadway Bookshop, while there is little rhyme or reason to its contents, it seems to contain every book you could ever need. I am tempted by a biography of Rasputin but settle for *Night Walks* by Charles Dickens, republished as part

a wonderful painting leaning against a pile of books of a highwayman partly done in felt. It's a piece of nineteenth-century folk art, one of 'The Earth Stopper' series by George Smart, and belonging to a man who works there. We leave wondering why you'd display a piece of art you owned in a bookshop. I will later see it or a near identical piece by the same artist, displayed at the Folk Art exhibition at Tate Britain.

Reaching the grey painted shop front of Persephone Books, with its simple font, is like reaching my destination on a pilgrimage. I've enjoyed many titles but never got around to visit their shop on Lamb's Conduit Street; in true London style, thinking there's always another day. Persephone publish out-of-print women writers, and their books have an unmistakeable plain grey cover with a vintage textile pattern printed onto the endpapers. After lengthy discussions with one of the staff I purchase *To Bed with Grand Music* by Marghanita Laski, about the wife of an officer in the Second World War who lives it up in London having fun with GIs while her husband is stationed in Cairo. The shop is everything I'd hoped, rows of grey books with recommendations and descriptions printed and tacked to the shelves. There are cushions printed in the designs from their endpapers and I feel that I want to stay here forever.

A–Z

I want to pick an area of London at random. I find exploring areas on foot without a plan and without expectations often takes me to the most surprisingly interesting places. It's a way of having a small adventure. My mother kindly donates an old A–Z to my cause. I flick through it, let it fall open at a page and stick a pin. My heart sinks rather as I've found myself at Pears Road in the heart of Hounslow. To my mind possibly the least inspiring suburb London has to offer.

I dutifully head out and find myself on an unassuming street of semi-detached houses. They are in a very plain suburban design that is difficult to place in an era, but are painted different pastel shades, creating confusing echoes of Notting Hill's pastel, terraced mews. I weave through streets that I can only describe as bland: browns, greys and beiges in the ugliest of functional styles. And yet, shiny cars sit by houses and many front gardens are thriving. I think of the phrase 'heroically plain',

which a friend of mine uses to describe people who don't let appearances stand in their way.

At Woodlands Road I follow the railway line. All trains are suspended, creating an uncharacteristic quiet. Behind the navy blue metal fence, cow parsley towers over nettles and near the ground blackberry blossom bursts through into my path. This creates a densely, detailed layered pattern interspersed by horizontal stripes of train track. I spot delicate nettle flowers and occasional bright red spiky leaves, adding a graphic roundness to the effect. Soon this abundance is caught up in the diamonds of a wire fence, barbed wire runs along the top and waves sleepily around it. This feeling comes to me, which I've felt on other walks, of being close to one of this city's many arteries. Life is spilling out with joyful abandon and winding itself around electricity and steel.

My A–Z indicates I'm coming to the Duke of Northumberland's River and I look forward to discovering a new waterway. But when I reach the footbridge to cross over to Octavia Road, it's hidden from view by dense trees and foliage. Peeping through into this long, thin hidden waterworld I can make out only a little.

I head down Howard Road, which is part of a purpose-built 1920s housing project. The houses seem somewhat shabby and down at heel. Some gardens are densely manicured while others are concreted over or contain rubbish. I think of how these south-west London suburbs – Hounslow, Isleworth and Brentford, etc. – have such a different character from the supposedly more picturesque Richmond, Chiswick or Kew. While containing occasional beautiful buildings and streets, these suburbs fit together less seamlessly than their prettier cousins, making them less

obviously appealing from an estate agent's perspective, but to me a richer ground for exploration.

Hounslow is far more culturally diverse than its glossier counterparts. From the 1960s South Asian immigrants started settling there, initially due to its proximity to Heathrow Airport. It gives the neighbourhood a cultural richness that much of the surrounding suburbs lack.

Modern estates of wharf style houses open up to the riverfront, which prettily follows a bend in the Thames. It has a harmonious mixture of riverside pubs, the old parish church, and Georgian and modern houses surrounded by trees, which hide the uninspiring buildings and office complexes behind them.

Across the water sits the Isleworth Ait, a small, tree-covered island. It used to be a centre for production of osier, a type of willow harvested to make baskets. Now it's a wildlife sanctuary that can only be reached by boat, and visitors are discouraged. Rusting old boats and workstations create a sense of its industrial past, they seem to be biding their time in this forgotten corner of London, waiting to sink softly into the mud. Below the raised riverfront, ramshackle houseboats are moored. I have a pint at the Town Wharf, enjoying the peace of this charming and unassuming enclave, while moorhens bob around in the water below me.

HAMPSTEAD
GARDEN SUBURB

FROM
EAST FINCHLEY
TO
WEST HEATH
VIA
HAMPSTEAD GARDEN SUBURB

The odd diamond shaped window or art deco door feature gives us a glimpse of what we are looking for. We're in search of Hampstead Garden Suburb, heading south from East Finchley. I'm not sure the part we wander into first, just north of the A1, is HGS proper. It's quiet, affluent. Perfectly manicured, rotund topiary surrounds immaculate 1920s and 1930s semi-detached and detached houses. Street names peep out through neat hedges.

Hampstead Garden Suburb is one of the country's finest examples of early twentieth-century town planning. Dreamt up by philanthropist Dame Henrietta Barnett and architect Sir Raymond Unwin, this was a purpose-built community, fuelled by a utopian ideology to create dwellings for people of all classes and income groups. Ironically, this area now has one of the highest property values in London.

Crossing over the A1 and we are now firmly in the Suburb. Turning into quiet streets, at first the houses are white with narrow curved windows, like narrowed eyes under dark brown roofs. At Litchfield Way the houses become brown brick, with arches, gentle curves and triangles. The roofs are oversized to almost fairy tale proportions. Geometrics are balanced out by gentle undulation. Every house is in a similar style but a different design. Above pristine lawns, wisteria creeps up the brown brick. Again the streets are empty and I feel enchanted by its

prettiness. The shapes and patterns around me are like those that I would draw. The idea that these spacious and beautifully designed homes were created for poor people seems unbelievable when these days even high earners are expected to live in soulless steel-and-glass boxes. Although they seem naïve now, there is something moving about the high ideals behind this project.

The unusual spires of St Jude-on-the-Hill and Hampstead Garden Suburb Free Church rise out of the trees as we walk up the hill. Standing on the green

between the churches, their distinctive shapes create an odd impression. There is something almost Viking-esque about St Jude's, with its great hall and simple tall spire. To our left the Free Church's seems to be made of severe triangles with a dome perched on top.

We both feel the atmosphere change. There is still nobody around, which is so strange. In similarly affluent and leafy Chiswick, where I am from, there are always grannies, retired gents or yummy mummies pottering about, walking the dog, but here there is no

one. The architecture, when applied to these large-scale houses of worship, becomes almost dystopian in character. I later discover that when Hampstead Garden Suburb was first created the Nonconformist and Anglican congregations all prayed together until they decided to build separate places of worship; perhaps this explains the somewhat threatening character of the buildings.

Shabbier Golders Green is a relief and we walk towards West Heath. We follow muddy paths and there are many more people around us now.

Finally reaching the pergola walk, built at a similar time to HGS by Lord Leverhulme and now fallen largely into disrepair, we wander through the forgotten raised walkways and the heath rolls out below us.

Hampstead Garden Suburb was built for all, but is now exclusive, its quietness eerie. The pergola and its surrounds were intended to be a private garden, but are now open to everyone. It's quiet here but it should be quiet. It's secret and almost forgotten.

GARDEN
SQUARES

The middle weekend of June is Open Garden Squares Weekend, where many of these usually private spaces are open to all. The garden square was built in residential areas in the Georgian and Victorian periods to provide relief from the urban environment. Permitted only glimpses, I've long had a fascination with these beguiling self-contained havens.

We start in King's Cross to go to the Collingham Gardens Nursery in the northern end of Bloomsbury. This isn't a traditional garden square, but half a hidden old graveyard used by a cooperative nursery run by local parents. With the stones still pushed up against the walls, the garden is a ramshackle world of low trees and bushes, sandpits and dens built from tree branches. Tents made from sheets covered in handprints hang from tree to tree. Old colanders and saucepans are stacked in plastic crates. Adam and I feel enormous joyful nostalgia as we wander through this place that invites us to make a mess, play and discover.

Although it's a small garden we feel that we are on a true exploration, before we go inside to shelter from the rain and have coffee and home-made cake.

We walk south, passing the British Museum, to Bedford Square Gardens. Usually closed to the public, it's one of the best examples of a Georgian London square. It contains tall plane trees and perennial shrubs of varying shades of green and grey-blue, but little in the way of flowers. Being on the inside is strange. Looking out, gaps in the plane trees make abstract shapes, framing segments of austere dark grey Georgian architecture. Through the railings we see glimpses of arched Coade stone entrances. It's cool and still.

Our next stop is Ridgmount Gardens, built for the Victorian mansion flats on Ridgmount Street. I've often been intrigued by its extreme narrowness. We discover it's beautifully planted with herbaceous borders and a woodland glade. As we wander through the trees, you feel you could get lost – the sense of being in a narrow space melts away.

Saying goodbye to Adam, I walk through Fitzrovia towards Park Square and Park Crescent. When I arrive I don't realise that the crescent can only be entered through the Nursemaids' Tunnel from Park Square and I walk around the smaller garden, peering through the stretched octagon-shaped holes in the railings that frame leaves and large yellow roses.

Park Square and Park Crescent are private areas of Regent's Park designed by John Nash in the early nineteenth century. I enter Park Square and it feels spacious and peaceful, the six lanes of Marylebone Road on the other side of the railings seem far away. The white grandeur of Regency houses peep in and I walk past beautifully planted beds where large alliums poke out of the top like lanterns and large lily leaves appear beside delicate little flowers. Wide spaces turn into small enclaves with a genuine sense of solitude.

Finally I find the sloping entrance to the Nursemaids' Tunnel, channelled with more alliums, verbena, poppies and periwinkles. Happy yellow roses bob in the breeze in the shrubs of Park Crescent, which is more formally laid out than its northern counterpart. I wander around briefly then make my exit. Back into the outer world of traffic and ticket barriers, to once again be looking in at these private hidden spaces.

KENSAL GREEN
CEMETERY

Before entering Kensal Green Cemetery from the West Gate, Ross buys a bunch of purple gerbera to put on graves. We decide they'll go on the most neglected.

On Cambridge Avenue the stones are fairly recent, made from shiny black marble with edges that seem brutally sharp amongst the weeds and in the soft, humid air. We are near the Catholic part of the cemetery and several large crucifixes begin to appear, one clad in stone ivy, one bearing a stone Jesus. I see the grave that will remain my favourite, in the style of a ruined gothic cathedral except model-village sized. Dandelion clocks, daisies and long grass grow up around it like a jungle.

Taking a right, we walk past more modern graves, covered in statues, garden gnomes and fake flowers. A large wreath spelling a girl's name. Kensal was the first of the 'Magnificent Seven' group of cemeteries, which includes Brompton Cemetery, developed in the Victorian era in response to mass migration from rural areas and the subsequent epidemics. It still has burials every day.

We sit in the crematorium's garden of remembrance beside Regent's Canal. Young trees are planted in tidy rows, and the garden is manicured and tasteful, so different to the melodrama that characterises most of the grounds.

Heading back into the heartland we clamber over low slopes where graves have slipped, being reclaimed by clay, sinking beneath the city. Kensington Gasworks looms up behind a lumpy hill, further confusing our sense of scale and orientation. I begin to feel we have shrunk, walking through like ants crossing a small garden.

The tombs become larger and a greater quantity of grieving stone women start appearing, their stone eyes rolling back into their heads. 'I will arise' is carved defiantly across the side of a domed roof mausoleum. For the Victorian emerging middle classes, these hyperbolic monuments to the deceased were a way of distancing themselves from the working class and immortalising their family name, encouraged by Queen Victoria's lifetime of mourning and monument building for Prince Albert. I decide I like the idea of this joyfully tragic celebration of death, that families were willing to

near bankrupt themselves for in order to have a more spectacular tomb than the dead family next to them. I imagine we are surrounded by men in top hats and a lavish black carriage pulled by decorated horses.

The gothic silliness of our surroundings and the sense of wandering freely and undisturbed around this museum of London's past puts us in high spirits. We sing 'Cemetry Gates' by The Smiths as we climb up onto the central chapel above the decaying catacombs. We pass a headless, moss-covered horseman, giant urns and a variety of Ancient Egypt inspired structures, including sphinxes, obelisks and tombs adorned

with scarabs. Grecian stone women and broken columns create the impression of wandering through verdant Roman ruins. Victorian Anglicans often saw crucifixes and other obvious Christian symbols as being too Catholic, so pagan or classical imagery became popular forms of grave architecture.

Passing the dissenters' area, we stroll back on ourselves to pay our respects to our favourite tombs. I lay one purple flower amongst the dandelions taking over the ruined gothic abbey and another on top of the 'I will arise' tomb, honouring this unrestrained morbidness that weather and ivy has rendered charmingly quaint.

WINDOWS AND WALLS

FROM
MORNING LANE
TO
BRITISH MUSEUM

It's spring and I'm weaving through the streets north of London Fields. My final destination is the British Museum. The terraced houses on Greenwood Road look charming in the sunlight. This area was largely built up in the Victorian era, where earlier buildings and land belonging to estates were broken up and demolished to make way for more urban housing. It fell into a great decline in the twentieth century, but has re-emerged in recent times as one of the most desirable places in London to live.

My eyes keep being drawn to windows. Blossoming trees are reflected in the glass, mixed in with the contents of the room or the patterns of drawn curtains. Images of cars and the houses opposite intermingle, and the images move and shift as I walk past, never the same for more than a split second, but encapsulating a sense of the environment on a rectangular pane of glass.

Pink blossom surrounding the north entrance to London Fields gives the impression that it is omitting smoke in the hazy light. On the corner wall of Gayhurst Road I see a letterbox peering from behind ivy. I look up at the brutalist diamond-patterned stained glass at the top of the front of St Michael and All Angels Church on Lavender Grove, and I pass a young silver birch tree, and see where its white paper bark had peeled off that it's terracotta coloured underneath.

On Middleton Road there are grey council flats on either side of me. Some of the windows have makeshift curtains made of sarongs or coloured sheets. The bright colours against the grey make an accidentally pleasing colour palette.

When I get to Kingsland Road, I look up at the windows of the SAE Institute. Some have wooden blinds pulled down, one is full with papers and

boxes of files stacked up. I walk down to Regent's Canal and see buildings just 'being' on the water. The reflections of large glass windows become a distorted silvery blur, shimmering on the water's surface.

Nearing Angel, I pass a red-brick wall on the side of an industrial building on which there are twelve bricked-up windows that stick out a brick's width

from the wall. These bricks are slightly more faded than the rest of the wall. It feels like the building has lost its eyes and skin has grown over. I often feel that buildings have souls, and for some reason I can sense this strangely modified structure's soul particularly strongly.

As I approach Farringdon I pass the back of a primary school. In four of

the windows I see the white and coloured paper backs of elaborate displays. On the top two, some of the pieces of paper are cut into bird shapes and on another they are cut into varied vague oval or petal shapes, surrounding rectangular pieces of paper haphazardly. I can only speculate on the content and educational purpose of these arrangements, but the pattern that they have created within the texture of this walk makes me happy.

I walk through the increasingly anonymous areas between Clerkenwell and the British Museum into the university vicinity. In a square of a divided and stained glass window I see a section of Georgian London rooftops beautifully encapsulated.

LINCOLN'S INN

FROM
ST CLEMENT'S LANE
TO
LINCOLN'S INN

Lincoln's Inn is one of the Inns of Court, which are associations for the barristers of England. They were developed and laid out a little like Oxbridge colleges, and there is certainly a sense of being in a dignified village of learning nestled within the hum of central London. After a quick drink at the Ye Olde White Horse on St Clement's Lane, we wind our way into the streets south of Lincoln's Inn Fields, along Carey Street and up into Star Yard. As we journey through passageways towards New Square we are winding into a historical heart of the city that still functions along a strict and honoured code. We feel like naughty trespassing schoolchildren.

New Square opens to a wide lawn with tall, brick buildings down one side. And a graphic, almost childlike tree grows up the sides of one of the building's walls. This provides a pleasing contrast to the solemn dignity of our surroundings. None of the Inns have a precise date for their founding but the earliest mention of them on record dates back to 1422.

The gates and the looming presence of the Great Hall are bathed in late afternoon sunshine, and we run happily past beautifully manicured flower beds containing peach-coloured roses. No one is around but we see a line of expensive motorbikes parked outside the hall, which strikes us as rather mysterious. Turning right towards Chancery Lane, we enter the more austere streets of Old Square. After the freshly mown lawns of New Square, the paved ground and pale grey Georgian terraces remind us of Paris.

Sauntering back around and up towards Lincoln's Inn Fields we come across a park official who reminds us that we only have ten or so minutes left until they close, for dusk. This walk has covered a comparatively small geographical area, yet we have wandered through a different world to that which we usually inhabit. We run down the soft curved banks of the main square of Lincoln's Inn Fields before leaving. I have a sense – as we walk out onto the traffic and chain restaurants of High Holborn – of walking out of the cinema after an engrossing film, or arriving back in London after a weekend away.

PORTOBELLO
ROAD

FROM
NOTTING HILL GATE
TO
WESTBOURNE PARK ROAD

Our destination is the launch of *Portobello Road: Lives of a Neighbourhood*, a book by Julian Mash, a friend. Starting at Notting Hill Gate Tube, we walk up past the stately white-and-cream Victorian villas with columns on Pembridge Road. Weeping willows, oak trees and London planes stand proudly beside them, and there is a confidence and wealth that permeates the sunny evening. In the mid-twentieth

century, many of these large houses were divided up into bedsits, having been abandoned as family homes when domestic service came to an end. Notting Hill became an increasingly culturally diverse part of the city, housing a large Afro-Caribbean community. It was only in the late 1970s and early 80s that this area became gentrified again, becoming home to professionals and wealthy bohemians, now increasingly to investment bankers and hedge fund managers. The sheen of extreme wealth has coated this area, diluting much of its previous, diverse charm.

We turn onto Westbourne Grove and peer through the window covering at paintings in the Whitewall Gallery. This wide street is full of designer boutiques and expensive cafés, all closed up for the evening. Elinor and I find it hard to find anything of interest to focus on, in spite of the area's obvious moneyed charms. The windows of Mercedes and BMWs reflect us back at ourselves.

Turning onto Portobello Road, we pop into the Earl of Lonsdale, an unpretentious Sam Smith's pub full of engraved glass screens, to give us

strength for the rest of our journey. Portobello Road has been a food market since the start of the nineteenth century and became an antiques market in the mid-twentieth century. Once a centre of counterculture, it now features many high street chains.

Red-brick, low-rise council flats appear on our right as we carry on. A couple of balconies are overflowing with floral window boxes and hanging baskets. This tension, between such mundane architecture and an

abundance of colour and beauty, makes me smile and I begin to feel a connection with my surroundings that has evaded me up until now.

We turn right onto Westbourne Park Road and there is a degree of understatement along this route. Victorian terraces are occasionally interrupted by 1950s buildings whose edges are softened by leafiness and sunlight. We pass one I feel a particular fondness for. Its surface is decorated with semicircular tiles in alternating brown and cream,

in order to brighten up a previously graffiti-prone part of the street. The colours seem in total harmony with the surroundings and lift our spirits for the last leg of our walk.

We arrive at the Idler Academy, a bookshop and centre of 'Philosophy, Husbandry and Merriment' nestled off the main drag. We find a room full of revellers and an excellently curated selection of books, and feel relieved and still hopeful for the continual re-definition of an area now at its height of gentrification.

with muted blue timbered areas. Red geraniums grow out of the balconies. It seems very of its era. Its lack of gran-deur in comparison to the area's sur-roundings seems to be an egalitarian beacon in this increasingly exclusive and inaccessible area.

Our eyes are met with a painted mural of brightly coloured geomet-ric shapes on a wall on the corner of Powis Gardens. This mural was created by Urban Eye in 2006, with residents from the adjacent Clydesdale House,

PEDWAY

FROM
ALDGATE
TO
POSTMAN'S PARK
VIA
THE PEDWAY AND THE BARBICAN

I am in search of traces of the Pedway. I start at Aldgate to follow the route of the London Wall, which is where the walkway was meant to have begun. It's difficult to ascertain ahead of time which remaining parts are still accessible, so I'm going to see what I can find.

The Pedway Scheme was an architectural plan for the City of London that came to the fore in the late 1940s. When rebuilding parts of the City after the Second World War, architect Charles Holden and planner William Holford devised a network of buildings with raised walkways to connect the city. This became part of the City of London Corporation's development plan, and all new buildings had to have first floor access to the Pedway. But the general public's overwhelming tendency to stick to ground level, and a lack of coherency in the plans, meant that by the 1980s much of the Pedway was abandoned. The City was left littered with dead end bits of walkway.

I make my way up Middlesex Street, heading west. A makeshift wooden wall – hiding another of the City's unending redevelopments – blocks off any view to my left and I feel like I am waking in a corridor. It is claustrophobic and disorientating.

At Bishopsgate I start walking down London Wall, past drunk Sunday people staggering around. I walk along past St Botolph-without-Bishopsgate gardens, past closed cafes and a hairdresser. As I hit New Broad Street my first bit of Pedway crosses over my path, but frustratingly it's part of a

private office. I keep going towards Moorgate passing through Finsbury Circus.

At Moorgate I finally see the mid-century tiles that hail the start of the walkway project. I climb up the steps, admiring the modernist pattern moulded into the concrete. Personally, I love the feeling of being on a different level while going from place to place, seeing buildings from unusual angles.

I'm walking towards the Barbican complex, a rare area of London where brutalism and utopian ideals not only survive but are treasured. It's one of my favourite parts of the City and I realise it's largely because of the Pedway. It gives a quiet sense of adventure, transporting you to a unique realm. Peering out as I walk along at second floor height, concrete rows of Gilbert House with their flower-covered balconies are ahead of me, and the medieval St Giles' Cripplegate is down and to my right. I come across the ceramic, mid-century abstract murals of Dorothy Annan. They have recently been moved from Farringdon Street, yet seem created for the many levels and angles of this space.

Walking past the Barbican lake terrace, I look down onto the sunken islands of gardens that remind me of a book my brothers had when we were children. Called *Our Future Needs*, it was full of sinister illustrations of planet Earth in a few hundred years' time. Next to the island a column of long grass sits in the water, both neat and wild. Families are having barbecues in the Thomas More residents garden and

while I know this is now an extremely expensive corner of the City, I feel as though I am seeing the vision of the idealised future imagined by those late 1940s town planners. It seems that twentieth-century town planning can only be deemed successful when privately owned by the wealthy, defeating its original objectives.

I look down at a surviving section of the original London Wall, over which moss and plants are growing. The cragginess of its edges seem exaggerated in comparison to the sharp angles of most of the surroundings. I go past concrete raised flower beds, all at many varied levels, and see Ironmongers' Hall, the Tudor black and white timber adding another sort of geometry to this strange landscape.

Now facing the Museum of London, arriving at the first floor by Pedway, I look up and the tip of the Lauderdale Tower, the Barbican's most imposing height, is peeking over like a small section of a jigsaw puzzle.

I descend the tiled steps, leaving the Pedway for the mundanity of ground level, down Aldersgate Street to the peach of Postman's Park. Remnants of the Pedway still exist between St Paul's and Blackfriars, but right now I am content to sit in this gently sloping enclave.

ARBROOK COMMON

It's nearly midsummer and although it's early evening it feels like mid-afternoon. Jonny and I enter Arbrook Common on the edge of Oxshott Heath. It's not real countryside, I know that. Yet as we enter and become enfolded by tall oak, ash and beeches, the strange enchantment of woodland emerges, a sense of walking into something endless. The light is streaming through gaps between leaves, creating a haziness. Pollen and dust float about before us.

We come to a clearing where young ash trees are planted sparsely, and dead and broken trees lie contorted amongst the nettles. A dimension of bleakness or melancholy emerges. The slim broken tree stubs remind me of Paul Nash's trees in his battlefield paintings.

Back into the heart of the woods we start to get disorientated, until we come across a group of teenagers who have set up camp. It occurs to me that

I have little ability in getting my bearings from the natural world. I revere nature, but can only read buildings and street names to find my way.

As we walk back the way we came, a golden evening light is falling over this most respectable of settings. I find something deeply romantic and melancholic about summer evenings in suburbia, the pristine blandness of our surroundings bathed in hazy gold.

As a teenager, this glow offered the promise of escape to somewhere grittier and more meaningful. Yet coming back to the suburbs after years of dwelling in Hackney, I feel that same longing for somewhere else and another life, even though I know I have the life I wanted.

It's both comforting and saddening to be here. We go back past the tall hedges to Jonny's house where, as if we are still fifteen, his mum makes us tea.

THE POST OFFICE WALK

We gather at 11 a.m. on a hot Saturday in July for the British Postal Museum's monthly guided walk. Under Victorian iron coverings at Smithfield Market, where meat has been sold for over 800 years, we admire two original telephone boxes designed by Sir Giles Gilbert Scott, which have become emblematic of our national identity. It feels strange to be discussing telephone box design in the blazing heat, in an empty market with the smell of flesh heavy in the air. I become fixated on the ventilation holes that make up the decorated crown of the K2 model.

We walk to St Bartholomew's Hospital and stand in the shade of the main square. A post box with two diagonally placed rectangles sits on the inside wall of the hospital entrance. On the other side is a red metal plate with a simple door, so the postman could collect the post without fear of infection.

Again some shady respite in Postman's Park, so named due to its proximity to the GPO, providing a lunch spot for postal workers. Previously a burial ground for St Botolph's-without-Aldersgate, it became a public park in 1880. We stand and listen to how in 1840 the penny post was began as a result of social reformer Rowland Hill's postal reforms. Prepaid postage led to the start of the stamp and the modern postman, and we're told that the original postman's red uniform coined the nickname 'Robin', and that this was the origin of the robin's association with Christmas. That such a slight reason led to such a deeply ingrained cultural symbol makes me laugh.

Our guide recounts a story of how, when postage was paid on receipt, a poor London woman explained how she worked out if a letter from her daughter was worth paying for. She'd hold it up to the light, and if she could see the writing in it she'd give it back knowing all was well, but if the paper was black-edged she'd know something was amiss. Today everyday life seems overrun with endless forms of communication and I find myself constantly seeking isolation and peace. I squint up at the sun and imagine divining my fate from seeing through an envelope.

HYDE PARK

FROM
MARBLE ARCH
TO
SOUTH KENSINGTON
VIA
HYDE PARK

We stand on the square beside the low, modernist Tube station at Marble Arch, the great archway behind us. Leo Hollis is a historian, the author of *Cities Are Good for You: The Genius of the Metropolis*. He is talking about Tyburn, the village that used to be located here. It was home to the gallows, where until the late eighteenth century the prisoners were taken from Newgate Prison and hung from the 'Tyburn tree' while huge crowds cheered on. The night before their execution, the condemned were carried by wagon along what is now Oxford Street and pushed into public houses along the way, which coined the phrase 'falling off the wagon'. It's a beautiful summer evening, tourists and commuters wander past us.

We step onto Speakers' Corner. Beginning when the Chartist movement used Hyde Park for workers' protests in the mid-nineteenth century, demonstrations and large-scale riots eventually led to this corner becoming the traditional place for speeches and debate. Recently reopened, on a Saturday afternoon many a zealot can be found holding forth, but tonight it is peaceful and innocuous.

Leo tells me about the Hyde Park Railings Affair of 1866, when members of the Reform League pulled railings out of the ground in order to gain access to the guarded park during a demonstration. He tells me that Karl Marx said that the Revolution would happen in Hyde Park and not Westminster. We

talk about how significant bloodshed and political violence has occurred in every part of this city, there is not spot with an un-tainted history.

As is so often the way nowadays, the part of Hyde Park directly south of Mar-ble Arch is closed off for a big music event. Instead we take a path down the eastern side, and our conversation turns to the role of the park as a pleasure garden, a place where the wealthy traversed in their car-riages to promenade, to be seen displaying wealth and status. I imagine ornate carriages wheeling past in the hazy sunlight amongst the tourists and commuters. We're just two more figures moving with the crowd, and I wonder if we are the only ones walking for the sake of walking and absorbing the rich life of our surroundings.

We turn the corner to walk along the south side, and through gaps in the London planes trees I see the Serpentine, part of the River Westbourne. Its glimmering surface is dotted with pedalos, green and white deck-chairs close to the banks. We talk about how cities are such creative spaces, about lives, experiences and minds bumping against each other like atoms, and how modern work places try to construct this spontaneous crea-tive melting pot with mixed results, and the work of Geoffrey West, who asks whether cities exist like living organisms.

Crossing over into Kensington Gar-dens, we discuss the definition of genuine public space, of how this is destroyed by CCTV cameras and fences and restrictions,

which discourage community spirit and responsible behaviour. We wonder where true public spaces exist. Leo talks of the picnic ground on the International Finance Centre in Hong Kong where amahs from the Philippines and Indonesia picnic every Sunday. We debate the multitude of giant glass and steel high-rises that are transforming the city's streets. Leo defends many of them, but criticises the way they disturb the continuity of the streets on ground level.

Against the shimmering sky, the unmistakable spiking silhouette of the Albert Memorial rises in the west. It marks the start of Albertopolis, the huge Victorian public buildings built on the proceeds of the great exhibition, all named after Prince Albert. We walk down Exhibition Road, a shared space where pedestrians have priority over the roads and cars use a reduced speed, creating a civilized peace amongst London's inhabitants. I think how these pockets of calm exist and will continue to exist amid centuries of struggle, upheaval and chaos. On that note, we enter South Kensington Tube station.

NIGHT
WALK

FROM
MORNING LANE
TO
UPPER STREET

It's a Sunday evening, I'm hung-over and going over to Amee's flat on Upper Street to watch the finale of a Scandinavian noir TV series. It's 6.15 when I set out but evening is fully established. There is a crescent moon in the sky smiling down at me. This is my very favourite moon shape, in fact one of my favourite shapes of all. There is something mildly comic about it, and reassuring. Maybe it's because, unlike the sun, it actually looks like its depictions in children's book illustrations. It makes me think of *Meg and Mog*.

I love walking at night, the world becomes an entirely different place. The bare bones of the structure of my surroundings are the same, but that is all. It's as if it's based on the same initial pencil sketch but then executed with an entirely different colour palette. It's a happy reminder that nowhere or nothing is ever exactly the same from one moment to the next.

Street lights make random patterns that shift with every step I take and my perspective changes slightly. I walk down Morning Lane and the Tesco sign looms, dominating the view. Inescapable. I look up at the tower blocks of the Trelawney Estate, at the random pattern created by windows being lit up. I like the fact that the story of who happens to be in on a Sunday evening is visualised in a pattern. Night does this, it visualises human stories.

There is not a great deal of actual dark around Hackney Central. It's really a sea of dirty yellow lights and reflections. I walk towards the Town Hall, to my favourite local night time monuments. The tree trunks in front of it, wrapped in blue lights, creating blue, floating light sculptures. By day, from a distance, the lights wrapped around the tree trunks look like tiny mussel shells clustered on rocks. The large Christmas tree is already up, colour coordinated in blue and silver.

I walk past London Fields. Shadows of trees and dotted lights. It's much darker and quieter. I wish I could walk through the park and become absorbed into the darkness. It's not just being a woman in this city, it's being a human being. But I feel wave of anger (at who I'm not quite sure) that, especially for a female, walking at night is considered, or probably is to a certain extent, dangerous. There is a liberating adventurousness to a night walk, the lack of visibility feels like real discovery and leads to very different thought processes to those which occur in daylight. To me anyway, to not be able to walk at night freely seems like a great loss and infringement to personal liberty.

I walk through the residential streets of London Fields then cross over to De Beauvoir Town. De Beauvoir is the area between Islington and Hackney. Initially built up as a residential area in the early nineteenth century, it contains tall elegant Victorian terraces and a more rarefied air to neighbouring Hackney, yet its industrial areas and the bleak, 1960s towers give it a more edgy atmosphere than Islington. I glimpse aspirational interiors, living rooms containing chandeliers, original fireplaces and mid-century lino cuts. Their desirability is multiplied when framed by darkness. Trees and plants under street lamps take on a weird quality, almost as if they are part of a very high-end model village or railway line, blown up to actual size.

I glimpse down into a flower bed, lit up by a street lamp. Rows of fresh leaves begin to peer up from hopeful, neatly planted spring bulbs. This otherwise cheerful sight is given a slightly sinister aspect by the ugly light. I imagine instead of daffodils and crocuses something monstrous might grow out of them.

Approaching Essex Road, I am nearing the warmth and comfort of Amee's flat, but part of me wants to stay in this in-between state of night walking forever. Walking in this city, houses, shops, vegetation and the landscape as a whole form shapes and patterns that alter as I walk through them. The city is more than a stage set for people to live out their lives, it is a moving and shifting process, and through walking I feel truly a part of this.

ACKNOWLEDGEMENTS

All my thanks to Hannah MacDonald for seeing a book in me before I did and giving me the opportunity to create *Ways to Walk in London*. And thank you for your support and encouragement throughout. Thank you Claudia Doms, your vision and design sensibility has made this book into an object of true elegance. Thank you to Charlotte Cole for such painstaking fact-checking and sensitive editing. Thanks to Leo Hollis for taking the time to take me on a journey backwards in time across Hyde Park on foot. Thank you to Caroline Cawston for sustaining me with good meals and cultural outings throughout this time.

Thank you to all my fellow walkers for giving up your time to stomp around the city with me and making this book such a pleasure to work on: Adam Winter, Elinor Cook, James Deeley, Ross Beard, Katie Gordon, Mark Philips, Sara Melin, Jonathan Portlock, Edith Serkovich, Caitlin Hinshelwood, Hannah MacDonald, Alma Haser, Philip Dennis, Caroline, Michael, Edward and Joseph Stevenson; and last but not least, the late Topsy, for being the best walking companion there ever was and I'm sorry that you were not able to join me on more of these.

If you have enjoyed this book and would like to find out more about Alice Stevenson or our other authors, please visit www.septemberpublishing.org.

September is an independent publisher; curating, collaborating and championing.